the UNICORN coloring book

by Jessie Oleson Moore, AKA CAKESPY ♡

"Why fit in when you were born
to stand out?"
— Dr. Seuss

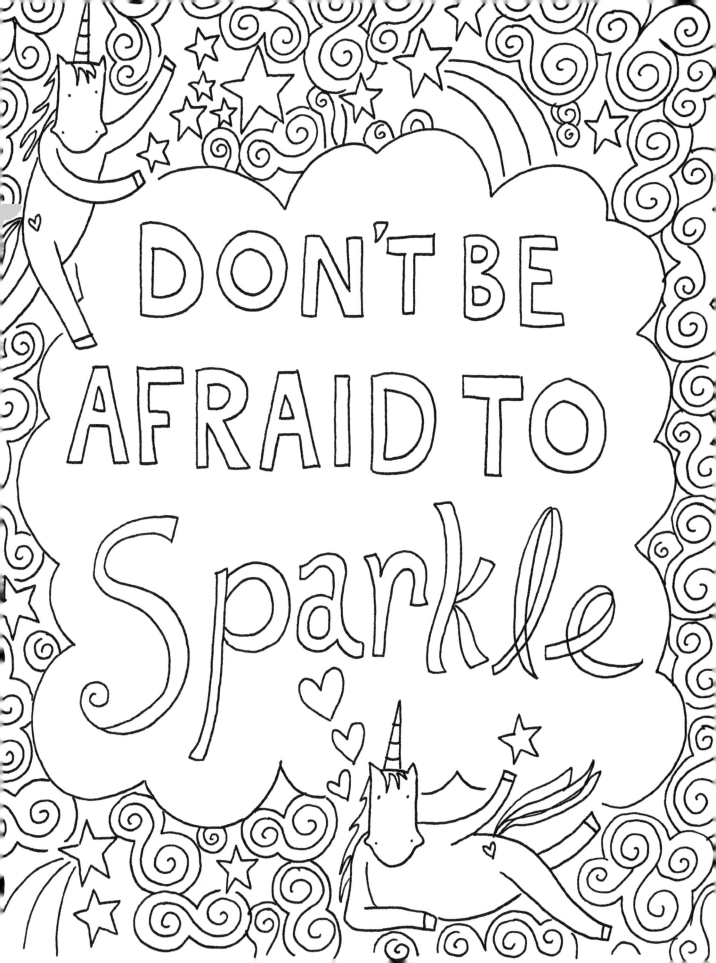

"Everything you can imagine is real."
— Pablo Picasso

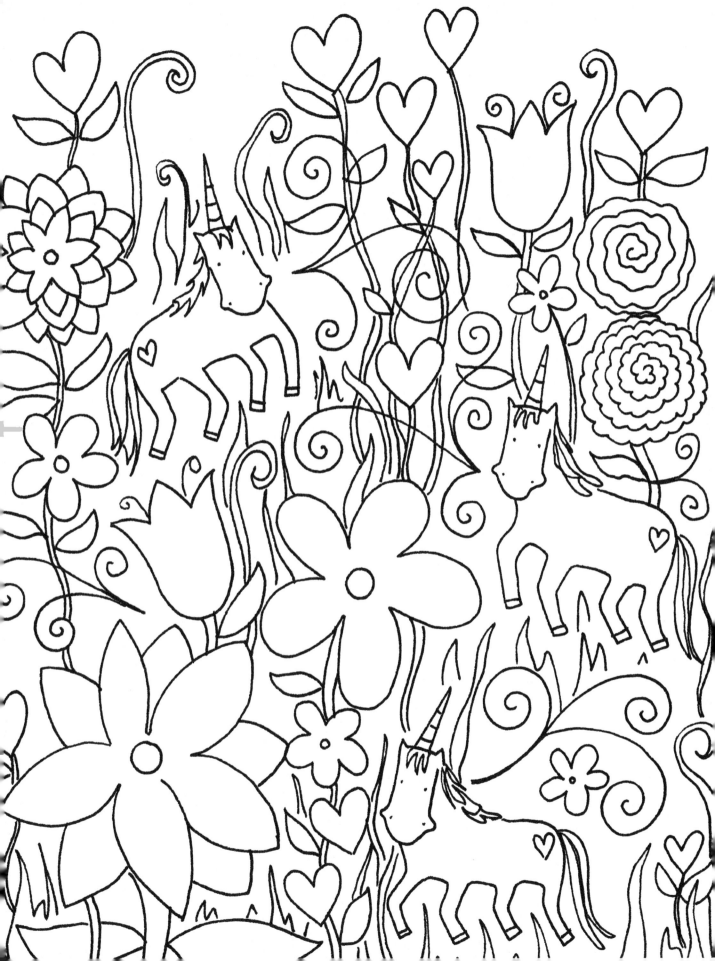

"Laughter is timeless.
Imagination has no age. And
dreams are forever."
— Walt Disney

Those who don't believe in MAGIC will never find it.

-ROALD DAHL

"Paris is always a good idea."
— Audrey Hepburn

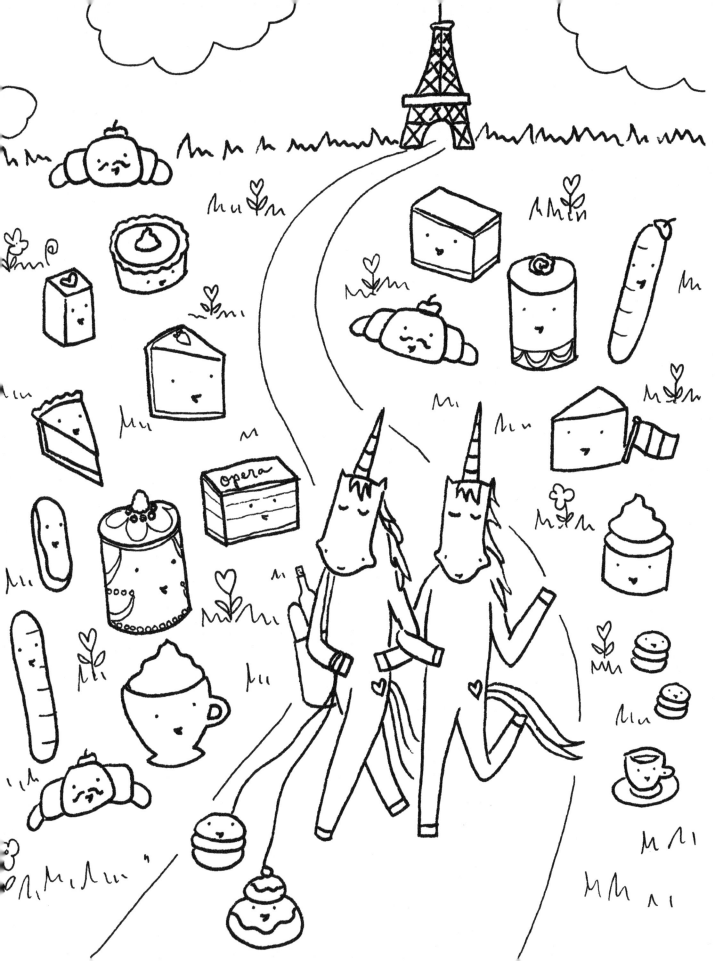

"Imperfection is beauty,
madness is genius and it's better
to be absolutely ridiculous than
absolutely boring."
— Marilyn Monroe

"We are what we pretend to be, so we must be careful about what we pretend to be."
— Kurt Vonnegut

"You know you're in love when you can't fall asleep because reality is finally better than your dreams."
— Dr. Seuss

"For every minute you are angry you lose sixty seconds of happiness."
— Ralph Waldo Emerson

"I like nonsense, it wakes up the brain cells. Fantasy is a necessary ingredient in living."
— Dr. Seuss

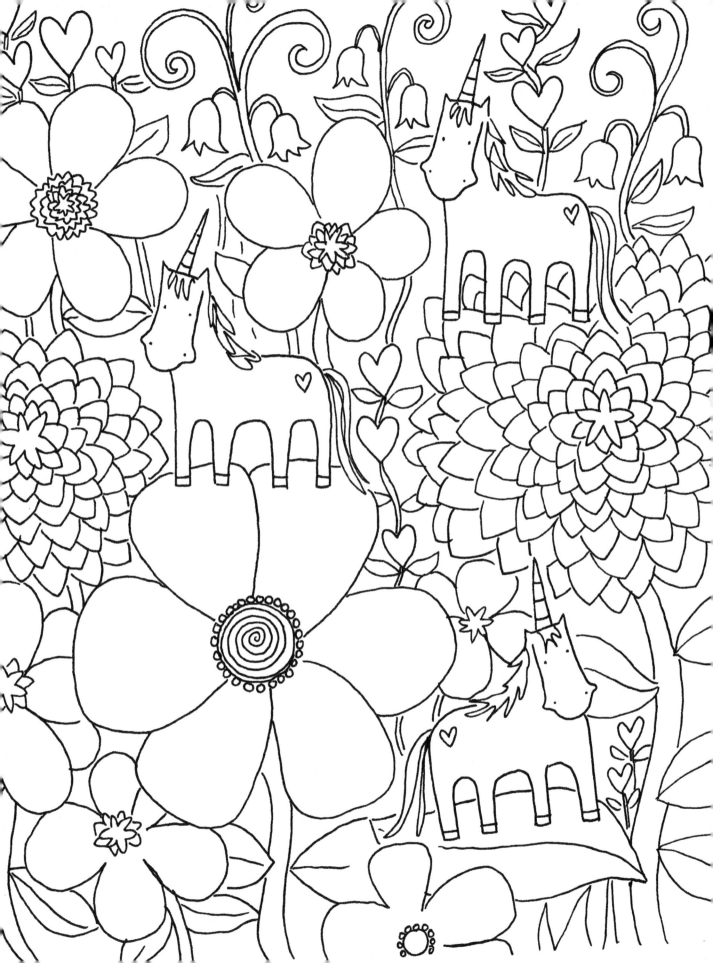

"You're something between a dream and a miracle."
— Elizabeth Barrett Browning

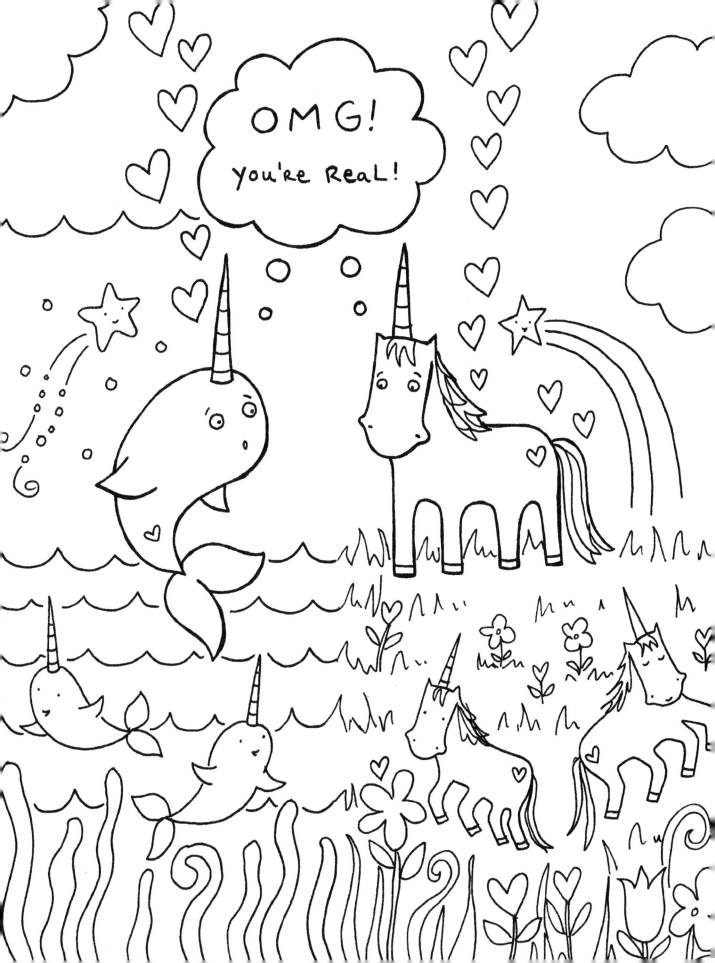

"I don't want to go to heaven.
None of my friends are there."
— Oscar Wilde

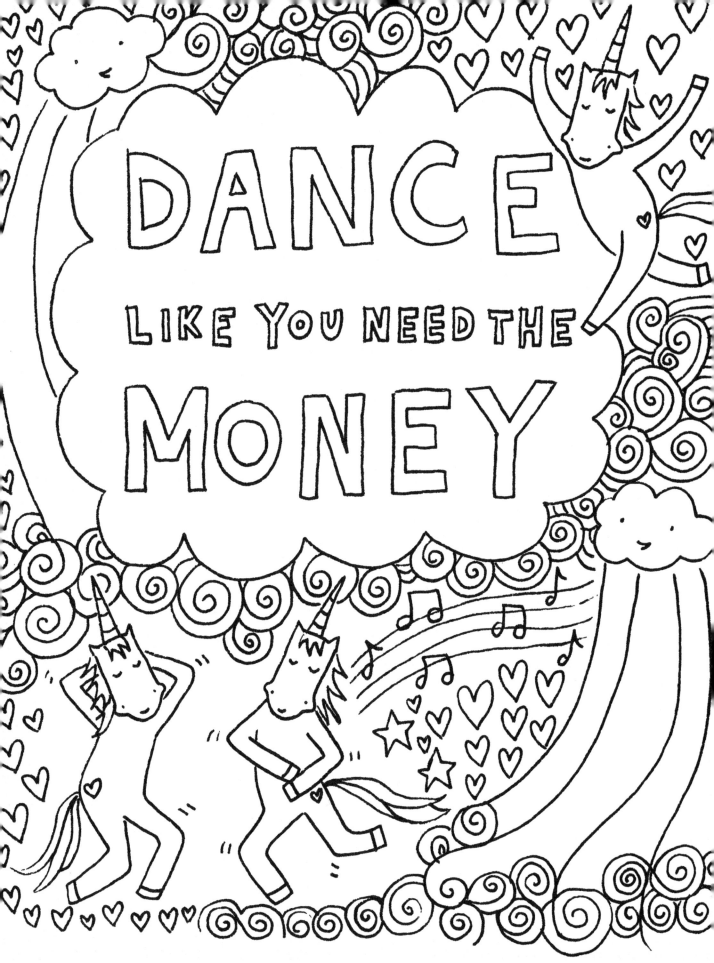

"Some people grumble that roses have thorns; I am grateful that thorns have roses."
— Alphonse Karr

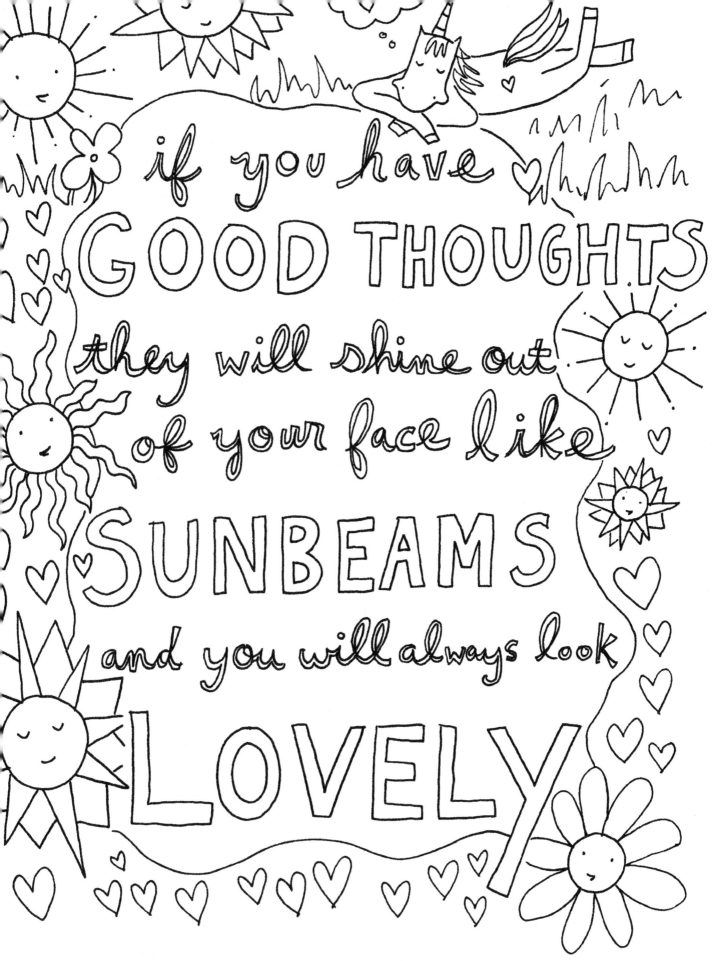

"Dreams, if they're any good,
are always a little bit crazy. "
— Ray Charles

"There are only two ways to live your life. One is as though nothing is a miracle. The other is as though everything is a miracle."
— Albert Einstein